D1576878

Essay by Sam Hunter, Exhibit by Bryan Ohno Gallery

Isamu Noguchi

BRYAN OHNO EDITIONS

In Association with the
University of Washington Press
Seattle and London

ISBN 0-295-98017-6

Distributed by University of Washington Press
P.O. Box 50096, Seattle, Washington 98145
www.washington.edu/uwpress/

It was the winter of 1982. In an obscure corner of the University of Puget Sound library, a fellow art student introduced me to a book on Isamu Noguchi by Sam Hunter. "Bryan," he said, "here is a book on an artist with a similar cultural background as you. His father is Japanese and his mother is American. He's one of the best sculptors of this century." With book in hand, I felt an immediate affinity and fascination with both his work and his background. I had always been aware of my own personal cultural isolation. Noguchi became my hero.

As youth knows no limits, I took it upon myself the following autumn to arrive unannounced at Noguchi's Long Island, New York, studio in the hope of meeting him and possibly becoming his apprentice. I was ready to interrupt or even forgo my education had this opportunity presented itself. His assistant, Niizuma-san, brought me back to reality when he told me Noguchi was away, but softened my disappointment with a tour of the studio. I was, and still am, captivated by the unforgettable scents of the workshop that were introduced to me that day. Sculptures in bronze, wood, and stone, with models for theme parks and stage sets, surrounded me — so much of his life's work.

The following winter, I made my second attempt to meet Noguchi — this time at his studio in Mure, Takamatsu, Japan. I clearly remember the early-morning 45-minute flight from Tokyo to Takamatsu. It was a poignant moment; the sun rose and struck Mount Fuji, creating a powerfully luminous landscape. When I arrived at the studio, Masatoshi Izumi, Noguchi's right-hand man in stone sculpture, greeted me with surprise. Again, I had missed him — and by only one day! I found consolation in the surrounding sculptural beauty that had been created over several hard-working decades.

Having failed to meet my "hero" in person, I returned to Tacoma, Washington. This time I decided to phone Noguchi, and was completely surprised to find he was listed in the Yellow Pages

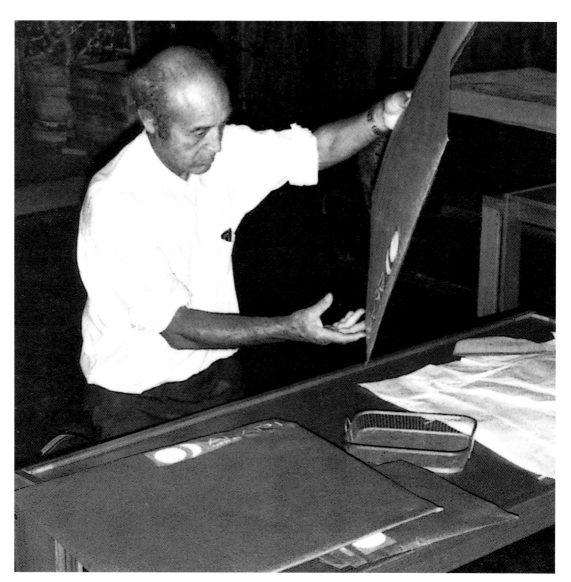

Isamu Noguchi, 1904–1988

under "Sculptor." My simple efforts were happily rewarded with a seven-minute conversation with this elusive man. It proved to be a most significant moment in my life.

Noguchi expressed his interest in our similar cultural identities. I broke the ice and, with the exuberance that I felt, expressed my great desire to serve as his apprentice. He replied that he didn't take apprentices. Desperately, I reminded him that he himself had been apprenticed under the Romanian sculptor Constantin Brancusi (1876–1957). He replied, "Yes, I was. Because of it, it has taken me 20 years to break away from his style. If you are interested in becoming an artist, don't work with artists; work with craftsmen. Learn their techniques, but the ideas must come from you."

I still live by these words and can now share them with my artists at the gallery.

— Bryan K. Ohno

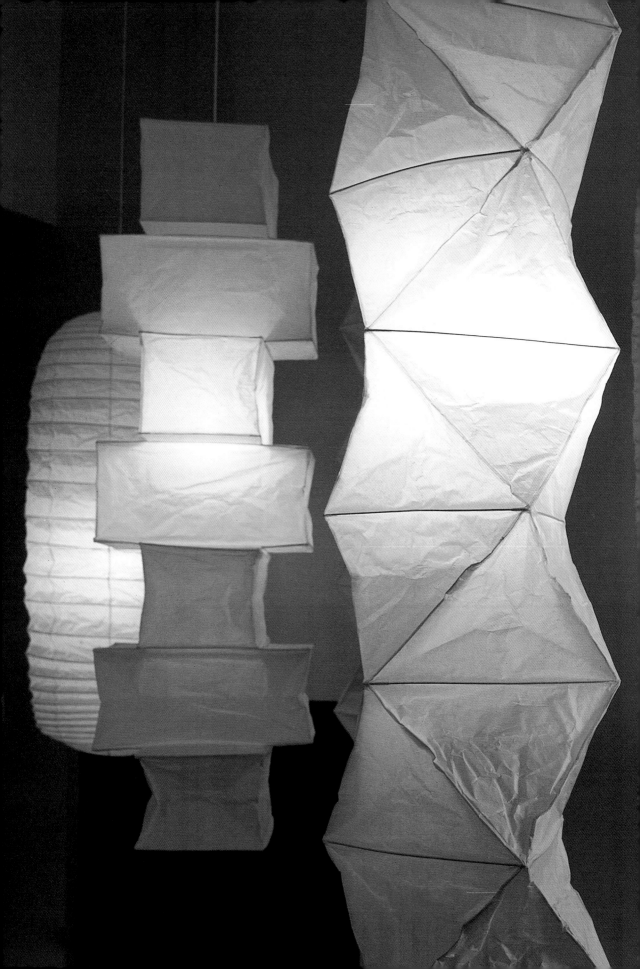

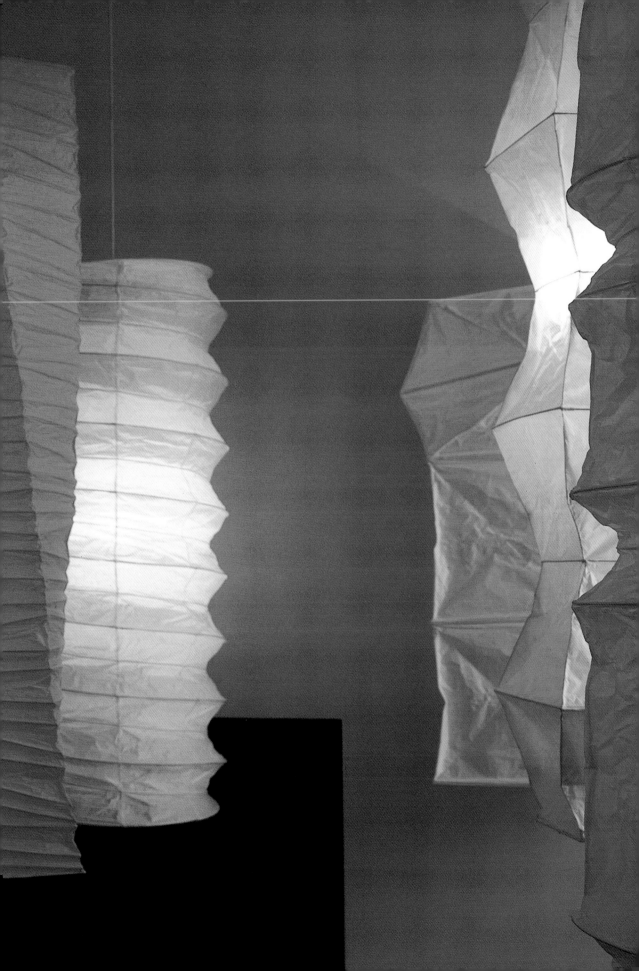

Isamu Noguchi's Unique Vision

By Sam Hunter

Isamu Noguchi's ties to Seattle are significant and enduring, giving him a special place in the city's affections, and extending from his youth to the present day. The works in Bryan Ohno's current exhibition explore important aspects of a prodigious and highly independent expression in materials as varied as the enigmatic *Cloud Mountain*'s galvanized steel and the elegant marble bands of *Little Id*. Noguchi did not create works only for a limited gallery space, needless to say, or in such traditional materials as the luminous, Zen-influenced forms of his paper-and-bamboo *Akari* lanterns, which are so engaging in the Bryan Ohno Gallery's ingenious installation by Seattle architect George Suyama and his assistant Jay Deguchi.

Noguchi has long been visible to a wide audience in Seattle through his monumental permanent structures. *Black Sun*, a granite disc of 1969, is situated before the Seattle Asian Art Museum in Volunteer Park, and has become one of the city's most beloved landmarks. The state of Washington can boast two other major commissions. There is the user-friendly, popular *Skyviewing Sculpture* at Western Washington University in Bellingham, and his powerful granite *Landscape of Time*, set out on Second Avenue at the entrance to Seattle's Federal Building. These three unusually diverse sculptures have placed the artist prominently in the public eye since their advent in the seventies and eighties.

Given Noguchi's stature as an artist spanning two cultures, the same generative sources that meet and meld so effectively in his highly visible public works provide an effective introduction to their smaller counterparts at the Bryan Ohno Gallery. In both expressions, public and private, one encounters his characteristic balance of opposing cultural forces, East and West, certainly. All of the works in Seattle, at Western Washington University, and at the Bryan Ohno Gallery embrace the more meditative Eastern ethos that Noguchi assimilated during his early, formative years in Japan,

Skyviewing Sculpture, 1969, Painted Iron Plate, 14' Height x 17' Width; Outdoor Sculpture Collection, Western Washington University, Bellingham

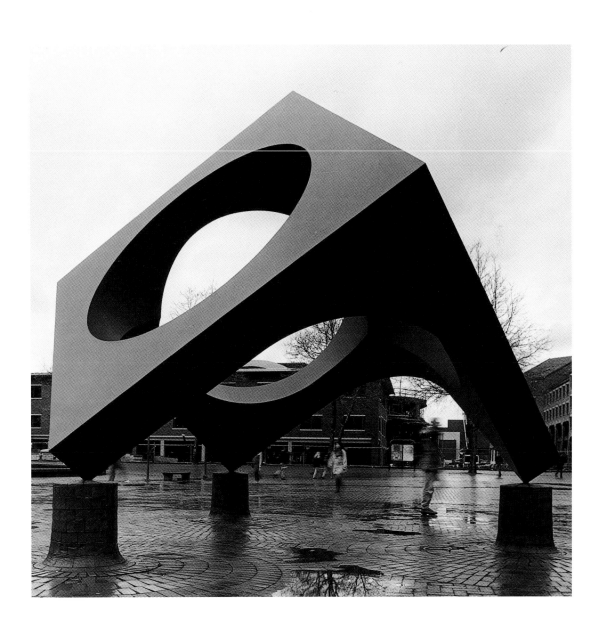

later extended through contact with his estranged father. Yet these nativist cultural influences are dramatically countered by a bracing modernism throughout his work.

It may be that the sculptures themselves, so visible here, speak eloquently of Noguchi's ongoing, affectionate links with Seattle. But underlying his commissions there is a deeper, more personal, historical encounter between the sculptor and city that occurred at a pivotal moment in his youthful development. Born in 1904 out of wedlock in Los Angeles to an American writer and teacher, Leonie Gilmour, and a touring Japanese poet, Yonejiro Noguchi, he moved to Japan two years later and was educated in Japanese and Jesuit schools for more than ten years.

He was just 13 when his mother decided to send him back to America, intending to enroll him in what she had understood to be a progressive school of the Montessori type, in Rolling Prairie, Indiana. The young Noguchi arrived in the States in 1918, greeting his birth land at the port of Seattle. Carrying his box of carpenter's tools, Noguchi continued on to Interlachen only to find that it was no longer a school; the First World War had turned it into an Army training camp.

He boarded with the local minister, and three years later graduated front the local high school. With the support of his patron, Dr. E. A. Rumely, who provided financial and intellectual support, Noguchi moved to New York and then spent three months in Connecticut in an apprenticeship with Gutzon Borglum. He enrolled in a pre-medical program at Columbia College that fall at the behest of Dr. Rumely, but also continued studying sculpture, at the Leonardo da Vinci School. Noguchi soon abandoned his pre-med path and began to produce skillful, if academic, nudes and portraits, such as his 1925 *Ondine*. His work was exhibited at the National Academy and National Sculpture Society when the precocious Noguchi, barely 20, was elected to the National Sculpture Society. His path shifted, however, in 1927, as he frequented avant-garde

galleries and won the Guggenheim Fellowship that took him to Paris. He became Constantin Brancusi's studio assistant and, influenced by the master's compact formalism, made his first carvings in stone. The change in his work, which already had shown a remarkable level of accomplishment, was stunning. From the naturalistic feminine curves of *Ondine*'s writhing torso to the severely abstract and geometric *Sphere Section* of just two years later, Noguchi plunged into the twentieth century and boldly set his course. The crystalline qualities of his elegant sectioned sphere are softened by the lushness of the marble he began to shape, and his sensitivity to both texture and tensile opposition were becoming manifest. His gleaming metallic *Positional Shape* of 1928, like the tactilely modeled head of Martha Graham, his great friend and interdisciplinary collaborator, and the sleek planes of another 1929 bust, of the visionary architect Buckminster Fuller, show him pushing the formal envelope still further, with astounding facility and alacrity. Influenced by Brancusi, Picasso, and the Constructivists, as well as other artists he met and exchanged ideas with, prominent among them Stuart Davis and Alexander Calder, Noguchi returned to New York in 1929. Not yet 30, he established the career whose rapid success would both link him to the leading avant-garde artists of the day and allow him to return to his Oriental roots, as he increasingly sought the essential harmony represented by the synthesis of opposites.

In 1931 Noguchi returned to Japan after 18 months studying calligraphic brush drawing with a traditional Chinese master in Beijing and seeking the counterbalance to the Western influences that led him to modernism. In Japan, he sought out the famous ceramicist Uno Jinmatsu for instruction. His interests ranged well beyond conventional boundaries in the East, as they had in the West, and the influences of the Orient, particularly Japan, would have profound effects on Noguchi and his work in Seattle. He became interested in prehistoric art and Zen gardens,

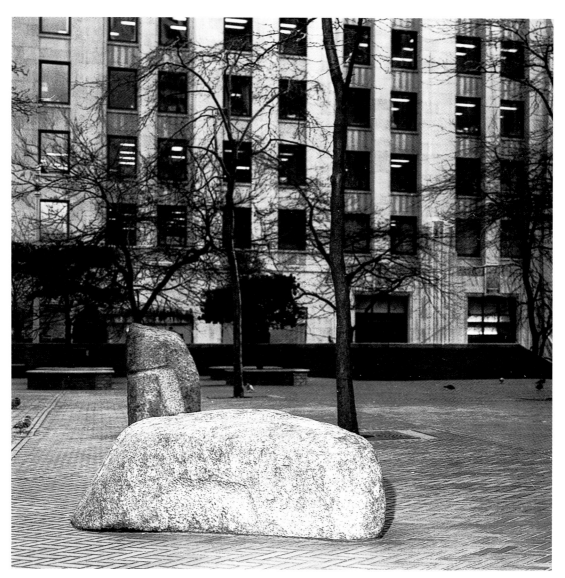

Landscape of Time, 1975, Granite; Federal Building, Seattle, Washington

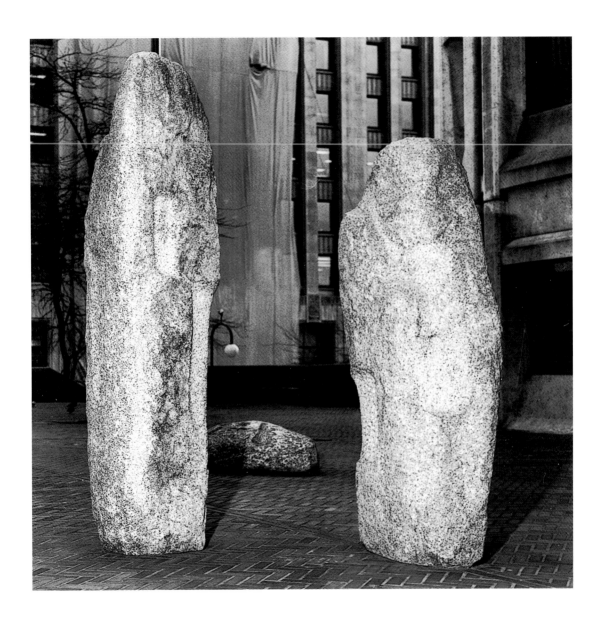

with their ritualistic arrangement of natural elements and centuries' old forms in stone and wood. He came to admire, and absorb, the respect for life he discerned in the traditional Japanese garden, and took special notice of the spaces that breathe between solid forms. Already the ground had been laid, literally, for Noguchi's formal and philosophical direction. He returned to New York in 1932 to create the distinctive open-form metal sculptures of the thirties that offer equal homage to the spirit of the Constructivists and to memories of the kites and origami he had seen and enjoyed as a child in Japan. In 1933, he created *Play Mountain*, the utopian urban design that first expressed his ideas on a scale so vast and ambitious that it prefigured the environmental movement of the sixties, and embodied his ongoing fascination with childhood joy and innocence.

The project, which used earth itself as its medium, doubled as a playground, an idea that was much in keeping with Noguchi's deft amalgamation of elements. Part landscape architecture and part sculpture, *Play Mountain* and its formal heirs both intruded upon the natural environment and acted as its logical partner; the built environment became a work of art, just as in Noguchi's intricate, life-affirming ethos, art inherently springs from nature. In the series of gestures that prefigure the aleatory and interdisciplinary activities of Robert Rauschenberg, Jasper Johns, John Cage, Merce Cunningham, and choreographer Graham, Noguchi tried to erase the line between art and life and yet bridge the gap between them, belonging to neither while accepting both. He brought serious formal statements out of the gallery and into the home, in the now legendary coffee table he designed in 1944 for Herman Miller and in his *Akari* lanterns, beginning in the early fifties. He drew on indigenous crafts to shape freestanding terra cotta sculptures in rounded, doll-like shapes, and he conjured up ephemeral moods with his fanciful and mythic sets for Martha Graham's vanguard dance company. And, always, the tensions between the naive

conventions of popular art forms and modernism at its highest levels of invention have given Noguchi's work its distinctive character. The suavity of his early circles and spheres, a series central to the formal vocabulary he later constantly expanded, may be seen in monumental form in *Black Sun*; there the massive disc seems both organic and fabricated as its elastic, truncated members seem to flare and recoil. These perceptions and executions are present too, perhaps more subtly, in his granite sculpture *Target* of 1984, exhibited at the Bryan Ohno Gallery. Smoothly contoured to contrast with the emergent eye-shaped carving that seems surprisingly and yet spontaneously to have been stamped on its surface, this blocky piece, measuring a diminutive 30 inches across its largest face, is nonetheless massive in scale, with a quite imposing presence.

Drawn from a private collection in Japan for the exhibition, it was first exhibited in 1985 at the Kasahara Gallery in Osaka, and later shown at the Nippon International Contemporary Fair in Tokyo in 1997. The appeal of *Target* is immediate, and visceral. Its texture is varied, its granular stone highly polished to set off the incised concentric lines that form the target image its title suggests. Or, perhaps, in another of the many interpretations that are possible, and, indeed, encouraged in Noguchi's interactive, open-ended statements, it could be taken for an eye. The polished section ends abruptly, however, at one side that seems to have sheared off suddenly and unpredictably, perhaps through the movement of the earth or a particularly clumsy strike from the sculptor's hammer. There is also a wedge-shaped section below the sculpture's gleaming granite skin, and below the target that is left rough, or *non-finito*, as Michelangelo put it for some of his figures only partially emerged from the rough-cut, quarried marble block at Pietro Santo. This typically open-ended quality of Noguchi's work is central to his esthetic, and belongs to the deliberately brute, anti-esthetic effects of his later stones. Some may seem merely weathered

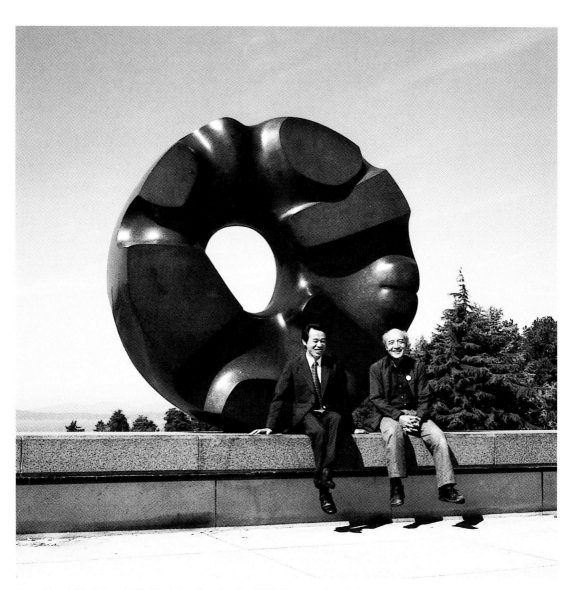

Noguchi and *Black Sun*, 1969, Black Brazilian Granite, 108'' Diameter; Seattle Asian Art Museum

or broken, as if from the passage of time or from some unknown cataclysm. Abstract though *Target* is, apart from its symbolic eye, it also taps into a rich vein of lyrical or narrative possibilities that link it formally to *Black Sun* and conceptually to *Play Mountain*, as well as to the Zen gardens that bring stone and wood together in formal, sensual harmony. Similarly, *Knife in the Rock*, a granite sculpture from 1970, presents a classical tabular form closely linked to Noguchi's landscape tables, which both function as autonomous stones and reference the gardens and natural landscape. Small, with a dimension less than 19 inches in length, its narrow, polished rectangular surface serves as a sort of table or altar into which the form that represents the knife of the title seems to be sinking, or maybe melting.

The references are multiple, and enticing, while in purely formal terms *Knife in the Rock* is a remarkable *objet de vertu*. Its alternating shapes and textures, like the refinements of the granite's natural grain and hues, are luxurious and soothing, accidental and crafted, simple and complex in their implications. The rather austere form invites reflection, arousing the senses but also challenging the intellect even as it invites the touch and hints at some poetic meaning or purpose: Is this Excalibur? Is it a playful description of a formation that occurred spontaneously in nature? Has the knife become one with the rock as it eroded over time, or is it the remnant of intense heat, which melted the knife? As in *Play Mountain* and the grand Moere Park in Sapporo, the sculptor's most ambitious realization of a playground/installation, completed only after Noguchi's death in 1998, the multiplicity of meaning is very much part of the piece. "I love the use of stone, because it is the most flexible and meaning-impregnated material," Noguchi has said. "The whole world is made of stone. It is our fundament. ... Stone is the direct link to the heart of matter—a molecular link. When I tap it, I get an echo of that which we are. Then, the whole universe has resonance."[1]

That resonance is evident as well in *Little Id*, the whimsical and sophisticated sloping column of black Belgian and white Bianco P. marble reflected in a mirror-like stainless stele. Lent by a Japanese collector, it dates from 1970 and radiates both an earthy, erotic energy and wit, as well a sense of irony diametrically opposed to the spirituality of *Knife in the Rock*.

The galvanized steel *Pylon* of 1981 represents Noguchi's more technological, constructivist side, as does another rather elegant Gemini G.E.L. steel sculpture at the Bryan Ohno Gallery, *Cloud Mountain* of 1982. Yet, while they lack the rich, sensuous textures of stone, the large, interlocking panels of *Cloud Mountain* express his interest in tactile qualities. Each of the sheets that have been arranged to suggest overlapping clouds, braced by a perpendicular fin facing the viewer, has pleasing humanizing contours and a surface whose patination doesn't completely veil its ability to reflect the general forms, colors and shadows of nature. The gently modulated surfaces of two spherical forms configure *Mitosis*, the 1962 bronze whose eight editions are in collections that include the Museum of Modern Art in New York. These reflective, biomorphic shapes act as "airports for light," as Cage famously said in reference to Rauschenberg's early *White Painting*, whose severe formal austerity only seemed to intensify the viewer's environmental awareness. As their title suggests, the two touching bulb-like forms might represent two parts of a single, infinitesimally tiny primitive being in the process of dividing into two parts. But they also present themselves as crafted objects, swelling forms that refer both to the human head and to ceramic vessels that still bear the humble potter's touch. Wonderfully simple, and yet remarkably sophisticated and complex in their varied sources, multiple references, and implications, the burnished spheres that form *Mitosis* are set nose-to-nose, one small and the other larger. Almost like parent and child playfully nuzzling one another, they add up to a unit that is powerfully

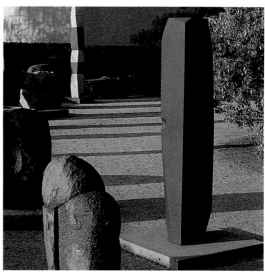
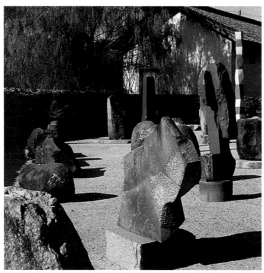

Noguchi's studio in Mure, Takamatsu, Japan

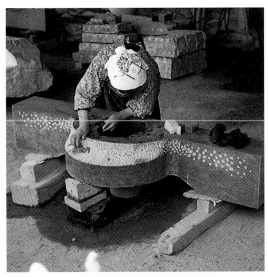

evocative; at the same time, set together on the rough plank at the Bryan Ohno Gallery, the two spheres also inevitably resonate with other, more exotic overtones. Like the stones in Kyoto's most famous Ryoanji Garden, serenely arranged with wooden elements and raked sand to symbolize the sacred, blissful landscape of heaven according to the Taoist sages, the spheres of *Mitosis* become part of nature itself.

"We all live in at least two worlds, inside-outside, the ideal/the practical," Noguchi said. "To me, that object I work on, with stone, I work on not alone but with history, with everything that I know and can call sculpture, that is to say, nature, the wind and the stars, you know, where we come from and where we go to, whatever you will."[2] All of those elements are present in Noguchi's Seattle sculptures, in monumental form in the public spaces and in more restrained form at the Bryan Ohno Gallery for the time of the exhibition. They are also embodied in works as ephemeral as the *Akari*, which underline his instinct for remaking the world, for placing his forms in a mundane environment and allowing interaction. And, on perhaps the grandest level, they are in his grand site sculptures that have just been completed posthumously.

Noguchi's vision spanned the gamut, synthesizing polar opposites and exploring the world around him, from the smallest and most intimate gesture in *Mitosis* to his monoliths. At its heart, however, a child's dreams and hopes remained, pure and always fresh. It is this creative innocence that is uppermost in the Mure Museum in the remote mountains of southern Japan, on the site of Noguchi's old studio, as it is in the awe-inspiring vistas of the Moere-Numa Park in Sapporo in Northern Japan. A more majestic and sculptural version of his unrealized 1933 *Play Mountain*, the new park on the northernmost Japanese island of Hokkaido may be the ultimate expression of Noguchi's genius. Built on reclaimed land, literally on a 454-acre dump, it transformed waste

into riches, and the earth itself into the sort of idyllic landscape that first enchanted and inspired Noguchi in Kyoto. He began the project in 1988, and left it incomplete at his death. His collaborators, who were always key elements in his projects, continued the effort, however, and it stands as one of his greatest achievements, and most extensive syntheses. "Real sculpture is what you don't immediately see," Noguchi told a Japanese interviewer shortly before his death. "Sculpture is what you find."[3]

Notes
1. Yoshiaki Inui, "Isamu Noguchi's Stone Sculpture" (*Isamu Noguchi*: Stones, Gallery Kasahara, Osaka, Japan, 1985), p. 7.
2. Sam Hunter, *Isamu Noguchi* (Abbeville Press, Inc., Publishers, New York, 1978), p. 164.
3. Carol Lutfy, "Noguchi's Last Gift" (*Architectural Digest*, 1999), p. 216.

"It is my desire to view nature through nature's eyes, and to ignore man as an object for special veneration. There must be unthought-of heights of beauty to which sculpture may be raised by this reversal of attitude."

— Isamu Noguchi

Bryan Ohno Gallery
September 2 – October 9, 1999

Exhibition Design by
George Suyama and Jay Deguchi

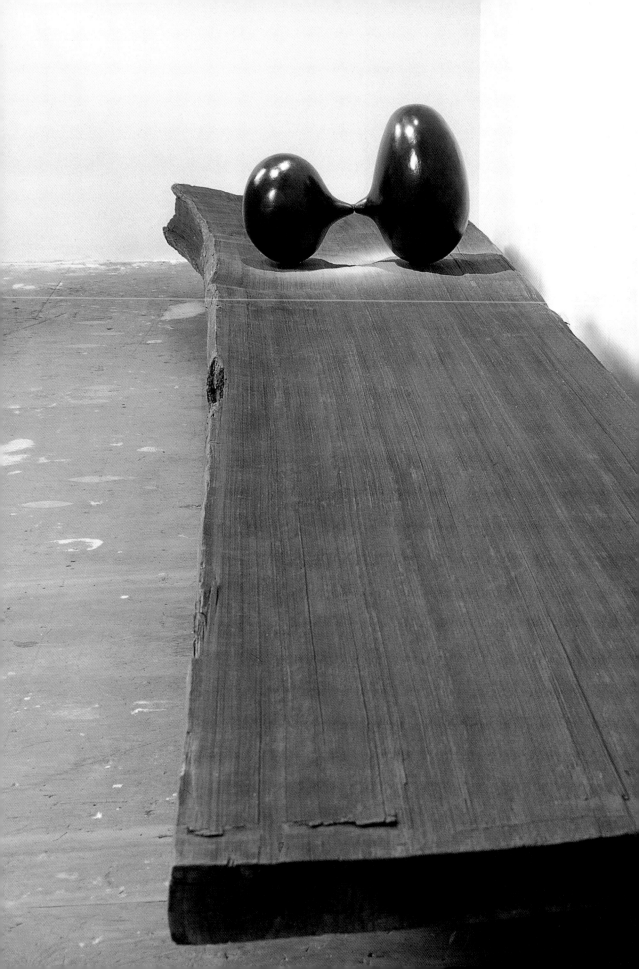

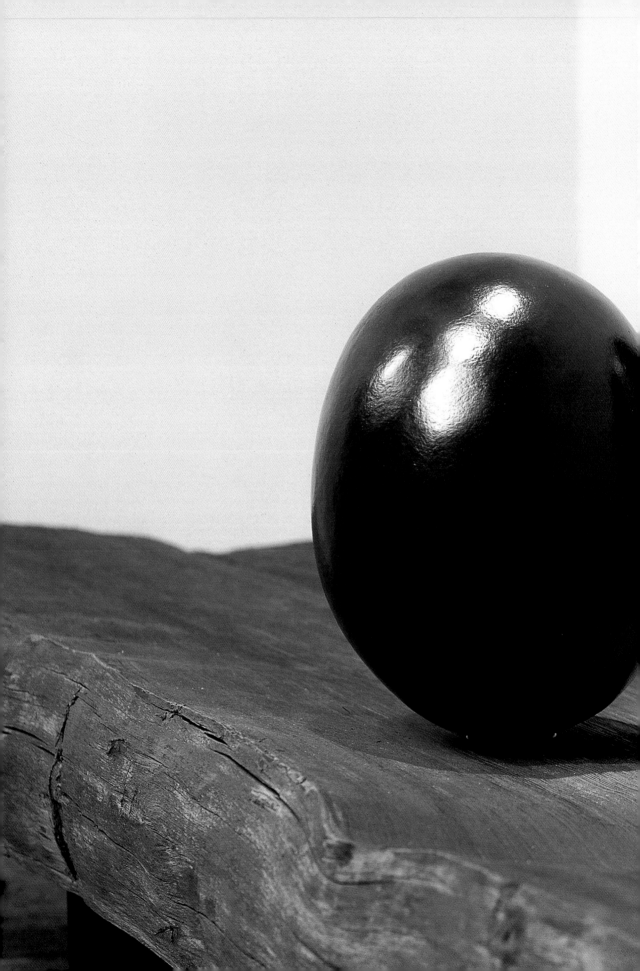

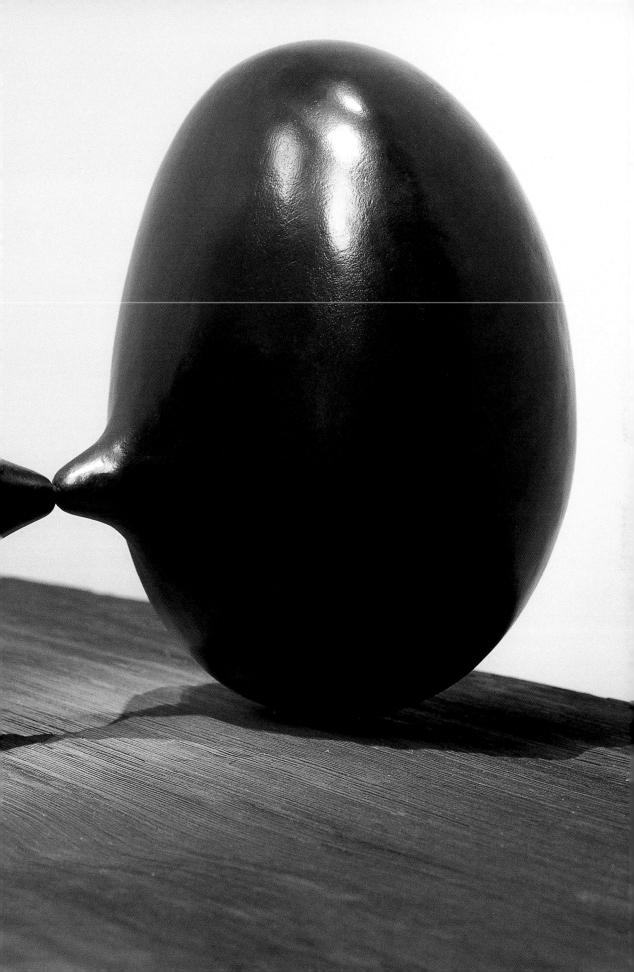

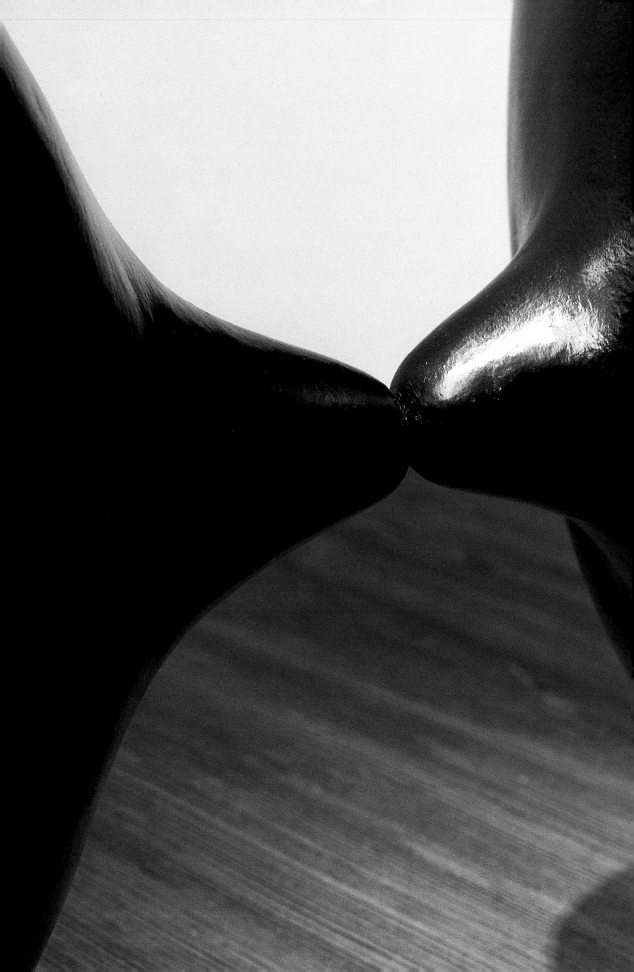

"The essence of sculpture is for me the perception of space, the continuum of our existence. All dimensions are but measures of it, as in relative perspective of our vision lie volume, line, point, giving shape, distance, proportion. Movement, light, and time itself are also qualities of space. Space is otherwise inconceivable. These are the essence of sculpture and as our concepts of them change, so must our sculpture change.

"Since our experiences of space are, however, limited to momentary segments of time, growth must be the core of existence. We are reborn, and so in art as in nature there is growth, by which I mean change attuned to the living. Thus adjustment of the human psyche to chaos. If I say that growth is the constant transfusion of the human meaning into the encroaching void, then how great is our need today when our knowledge of the universe has filled space with energy, driving us toward a greater chaos and new equilibriums.

"I say it is the sculptor who orders and animates space, gives it meaning."

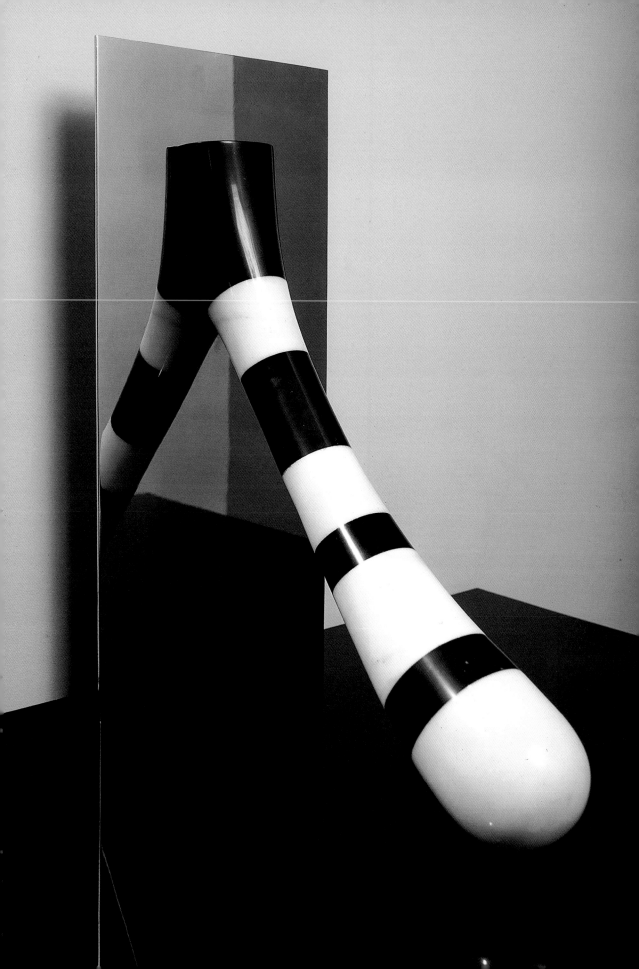

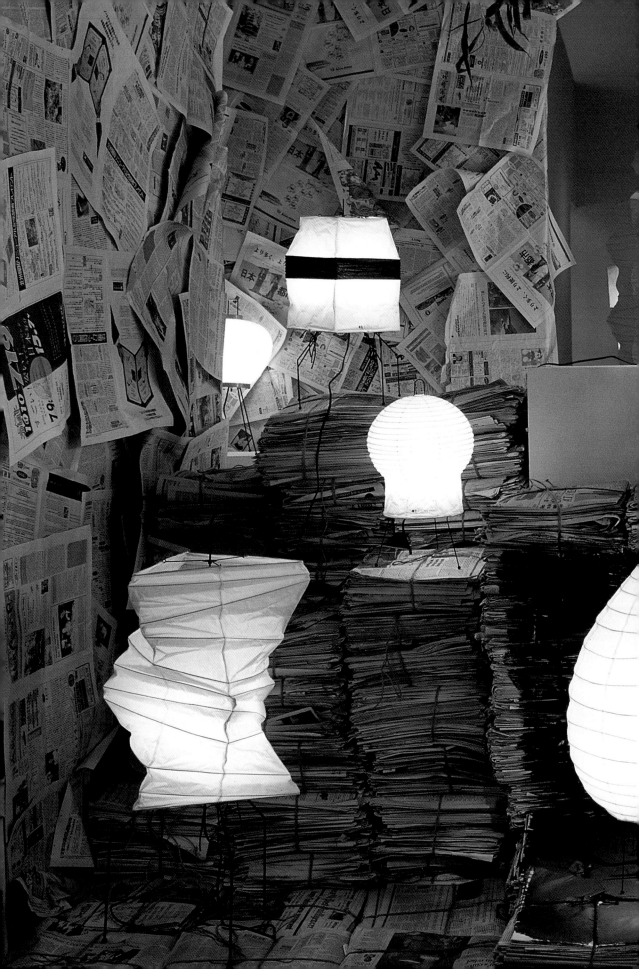

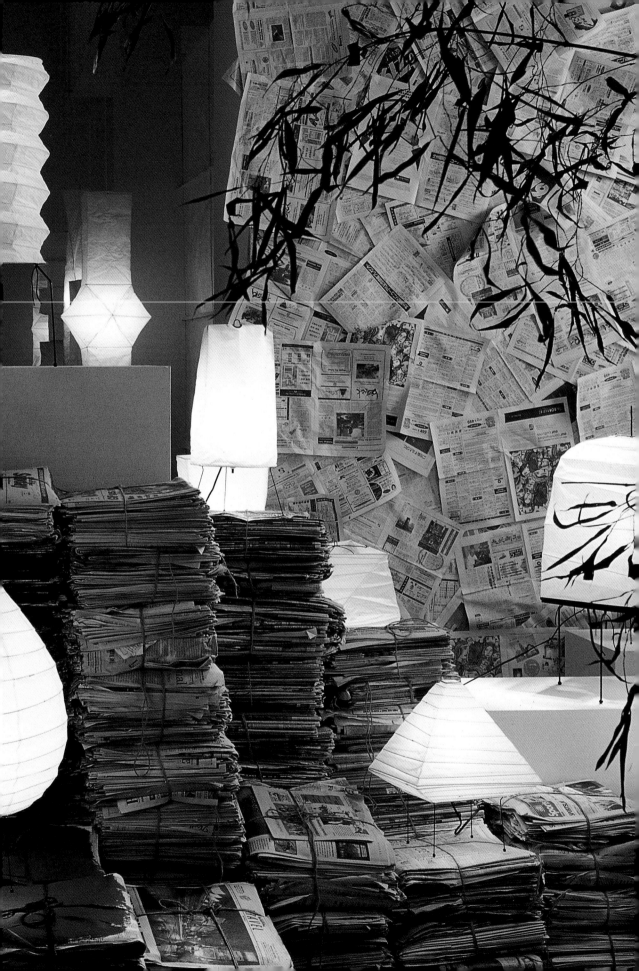

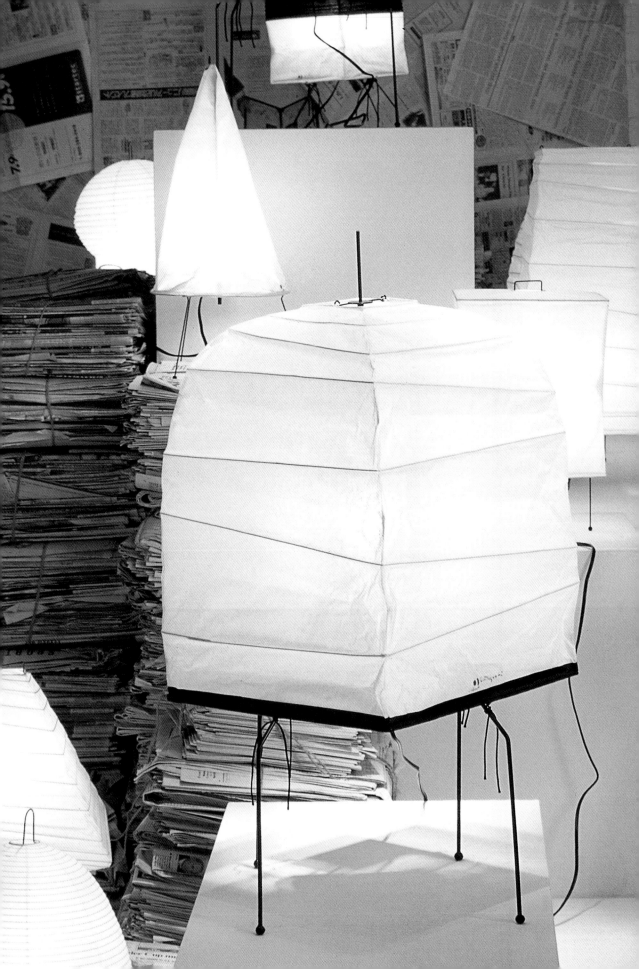

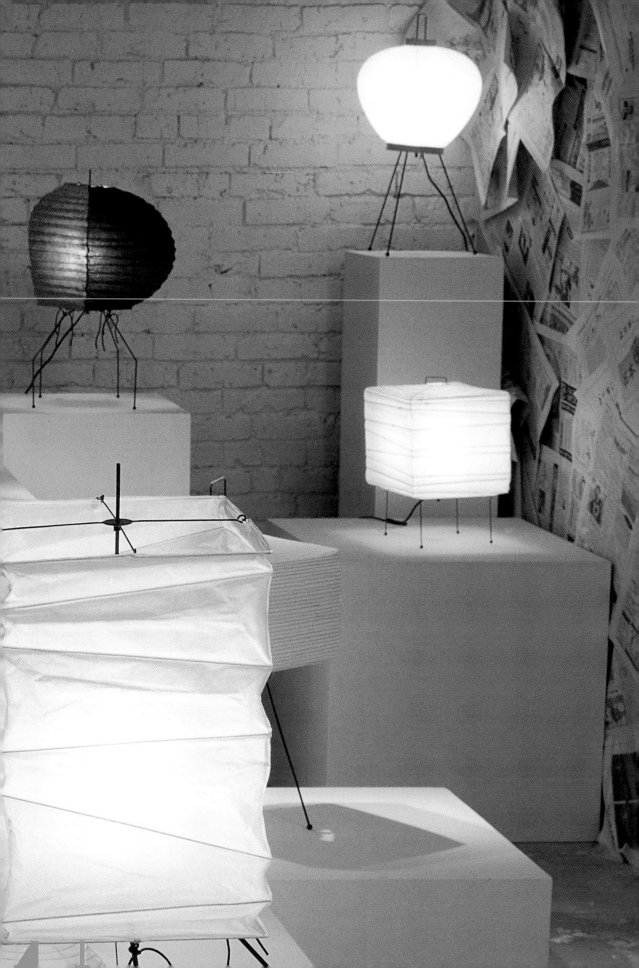

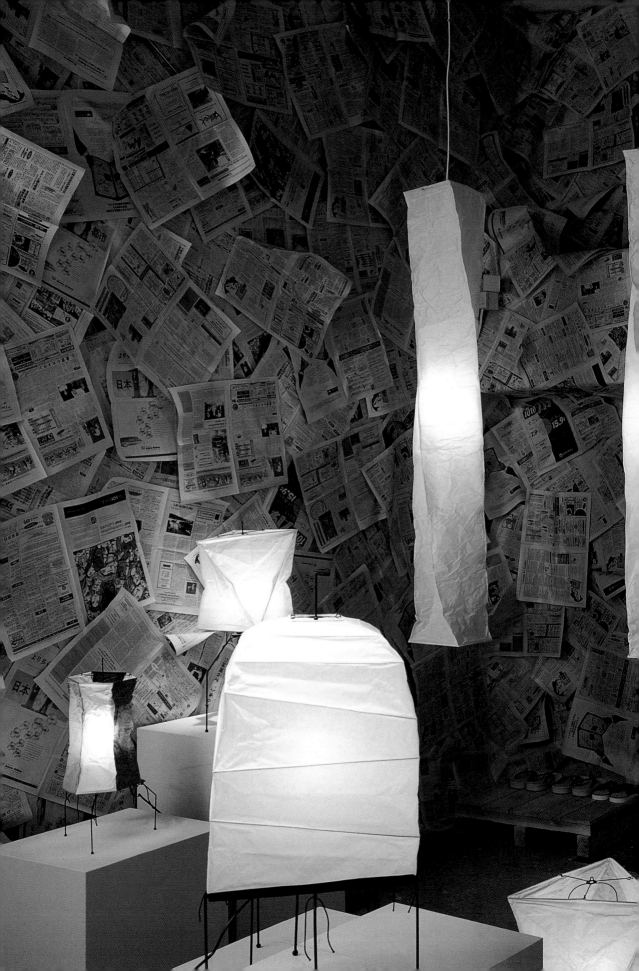

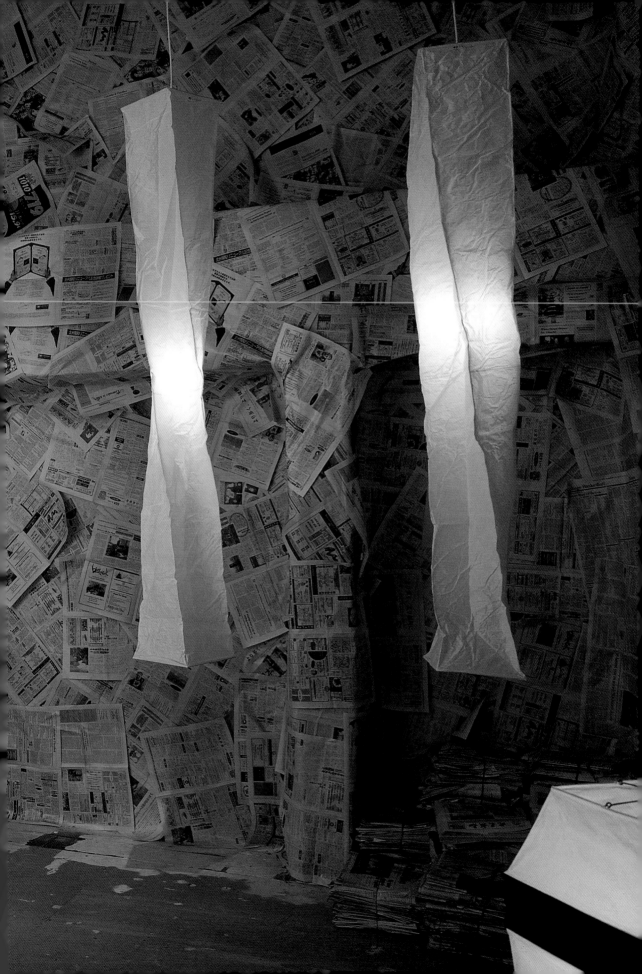

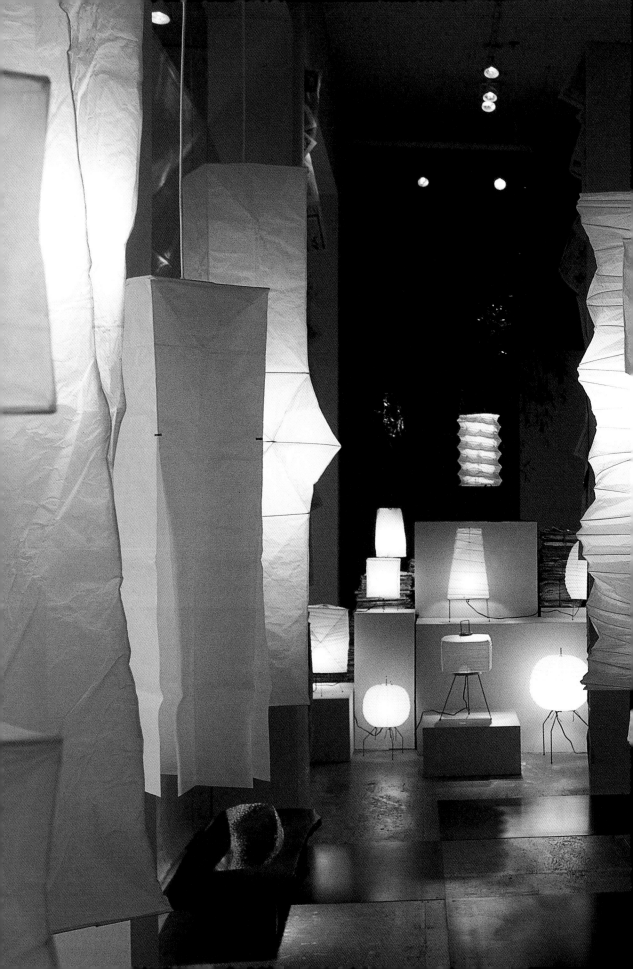

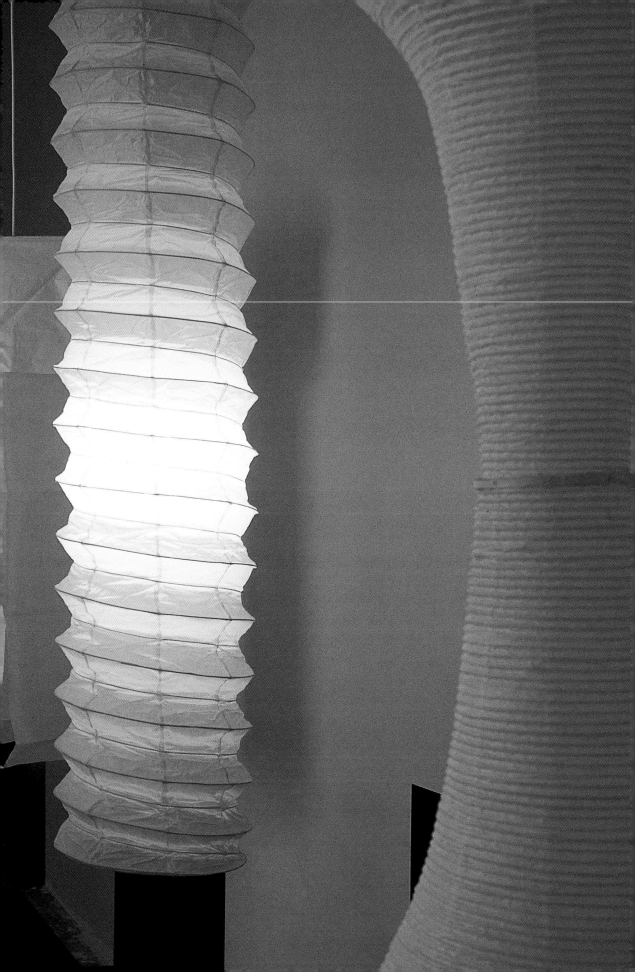

"*Akari*, which I coined, means in Japanese light as illumination. It also suggests lightness as opposed to weight. The ideograph combines that of the sun and moon. The idea of *Akari* is exemplified with lightness (as essence) and light (for awareness). The quality is poetic, ephemeral, and tentative... They do not encumber our space as mass or as a possession: if they hardly exist in use, when not in use they fold away in an envelope. They perch light as a feather, some pinned to the wall, others clipped to a cord, and all may be moved with the thought."

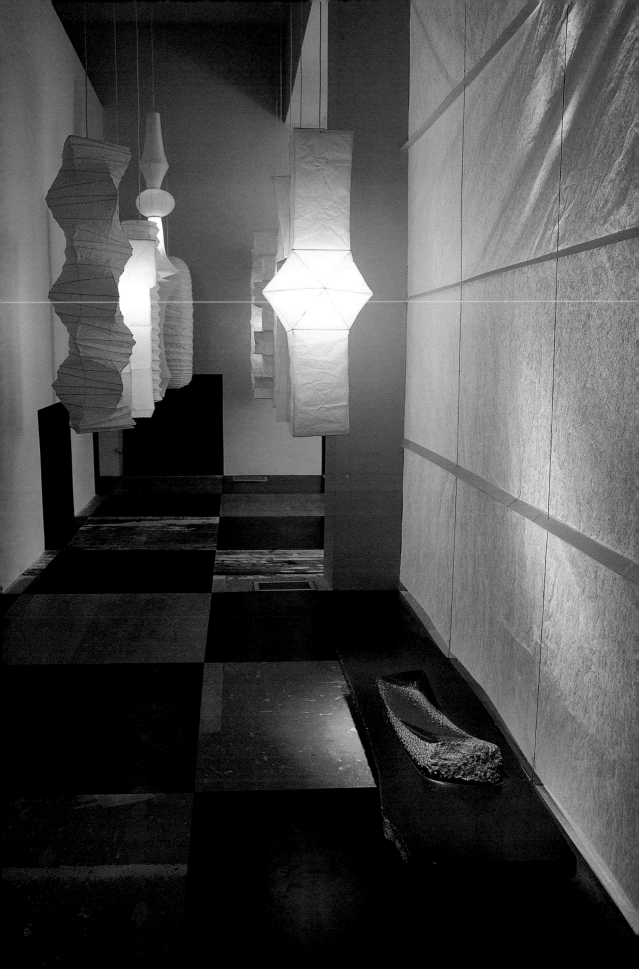

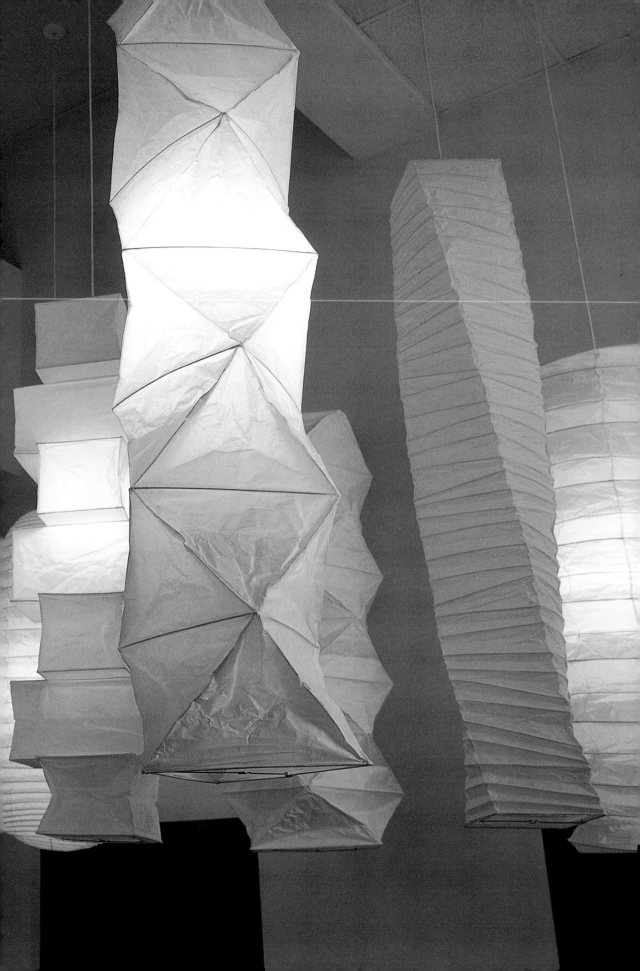

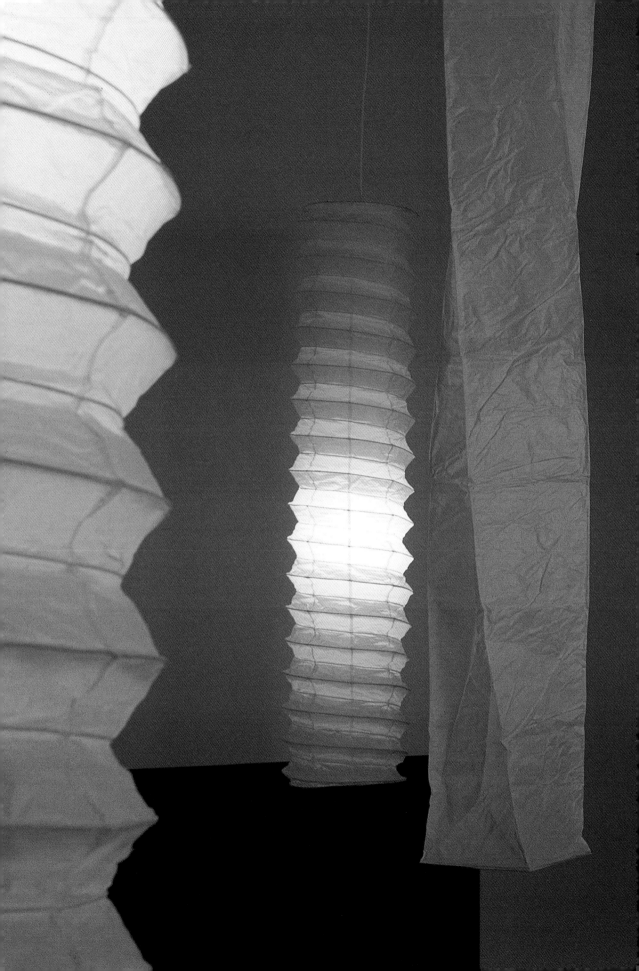

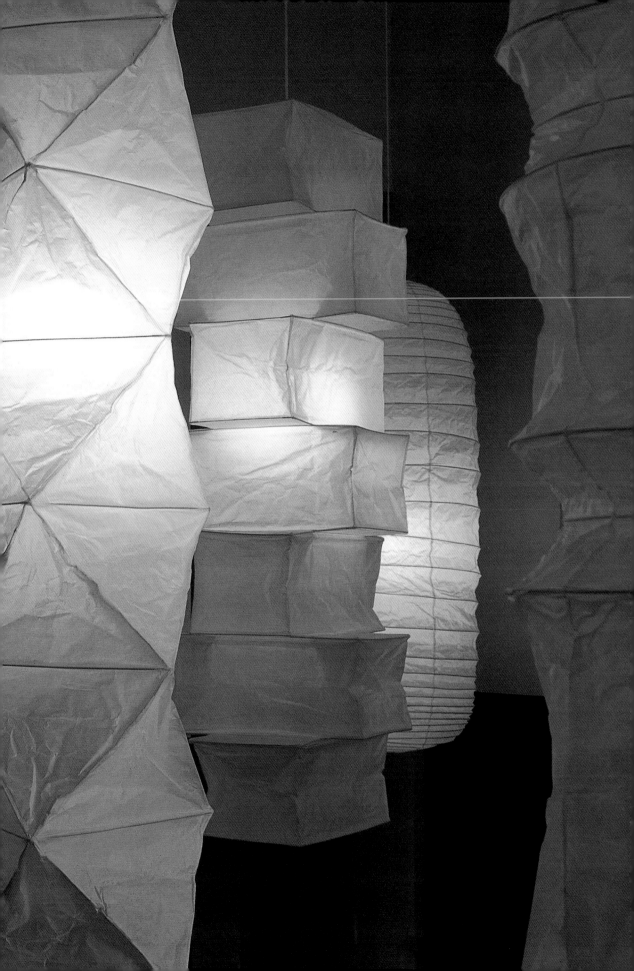

"Everything was sculpture. Any material, and idea without hindrance born into space, I considered sculpture... I thought of a room of music and light, a porous room within a room — in the void of space."

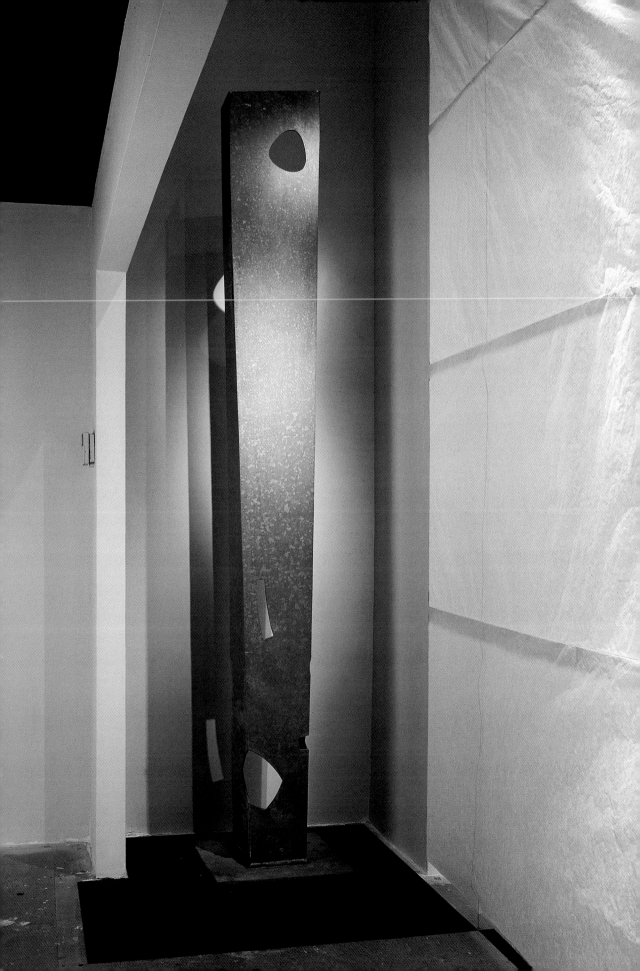

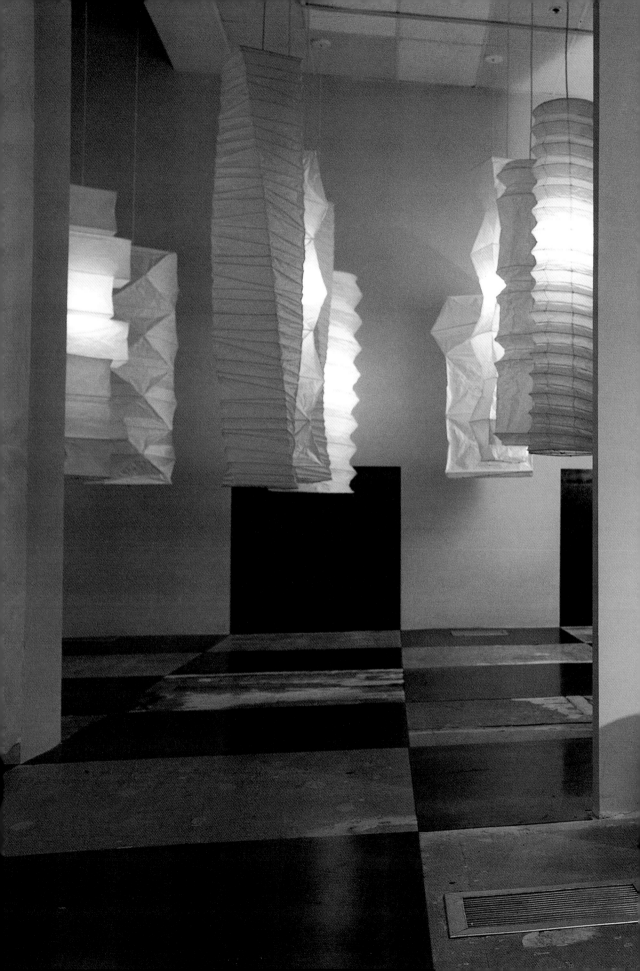

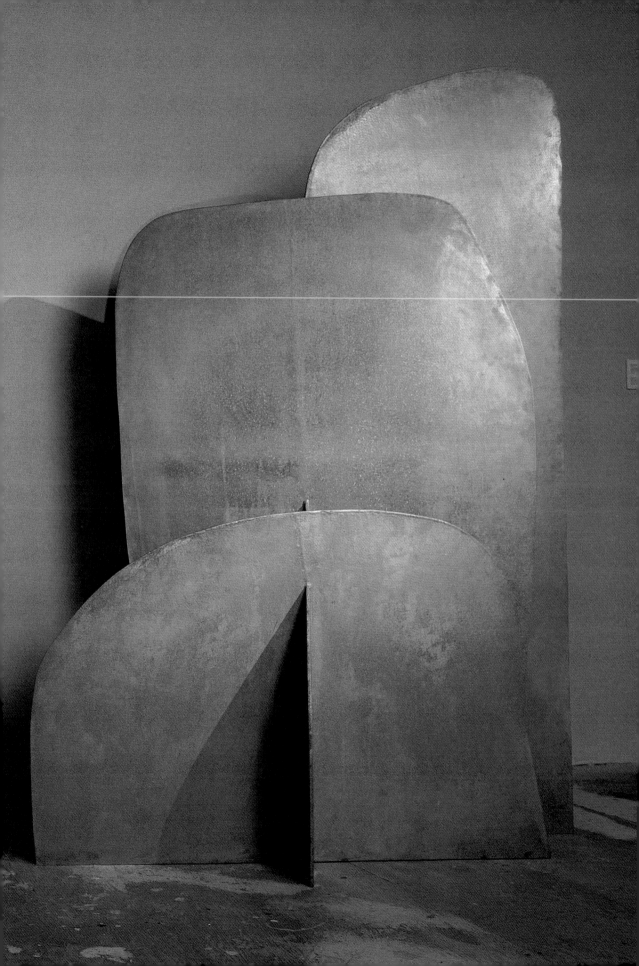

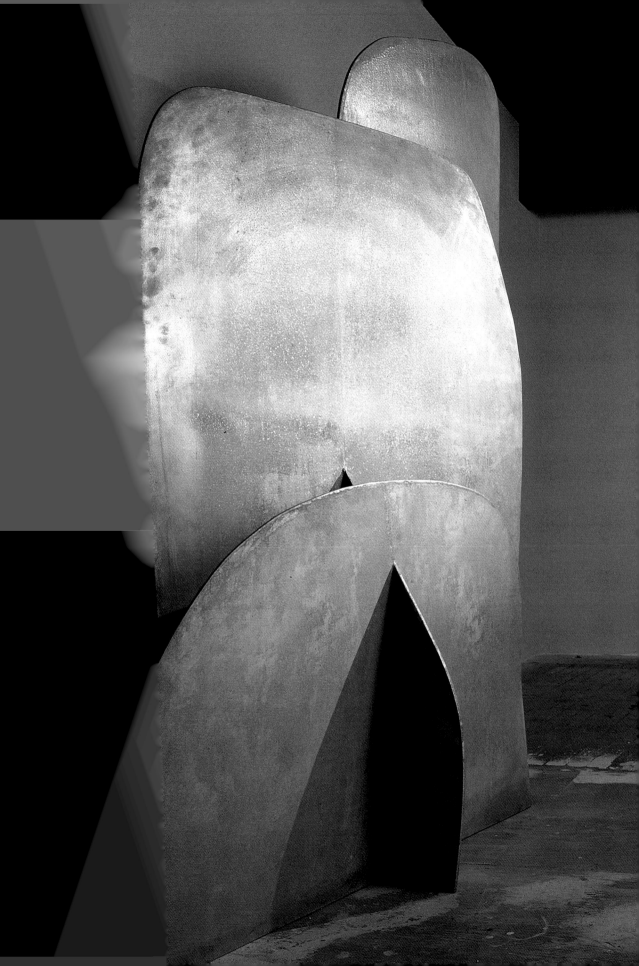

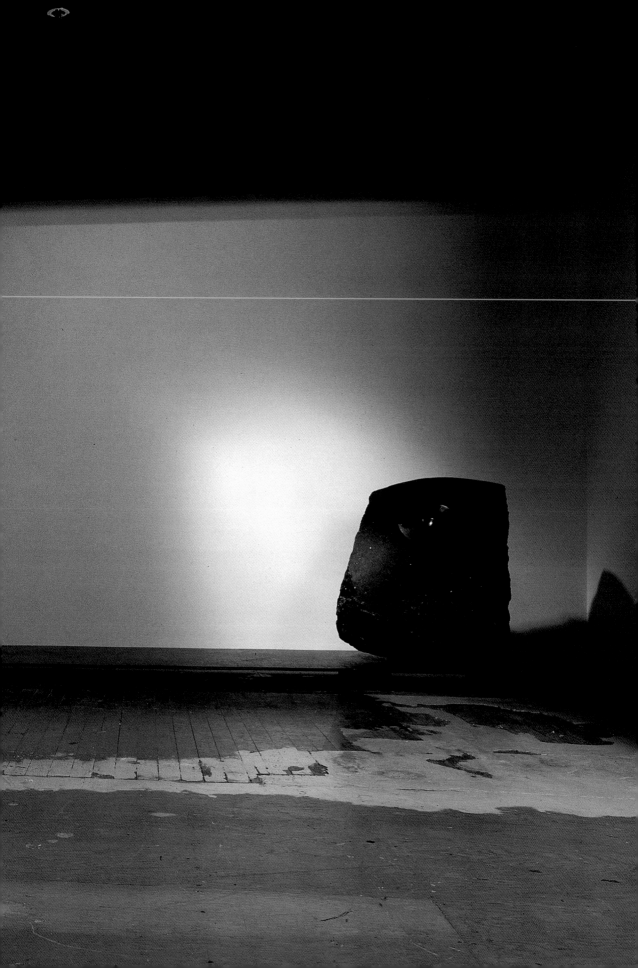

"I love the use of stone because it is the most flexible and meaning-impregnated material. The whole world is made of stone. It is nothing new. It's as old as the hills. It is our fundament. And since it has such a long tradition of use, you can compare things to each other very well. You start making things out of steel. It has a short tradition. You may be the originator, or you may be the end of the line. Who knows? It depends on how the material lends itself to creation. Stone has a quality of durability. It does not pollute. It merely goes back to the earth naturally."

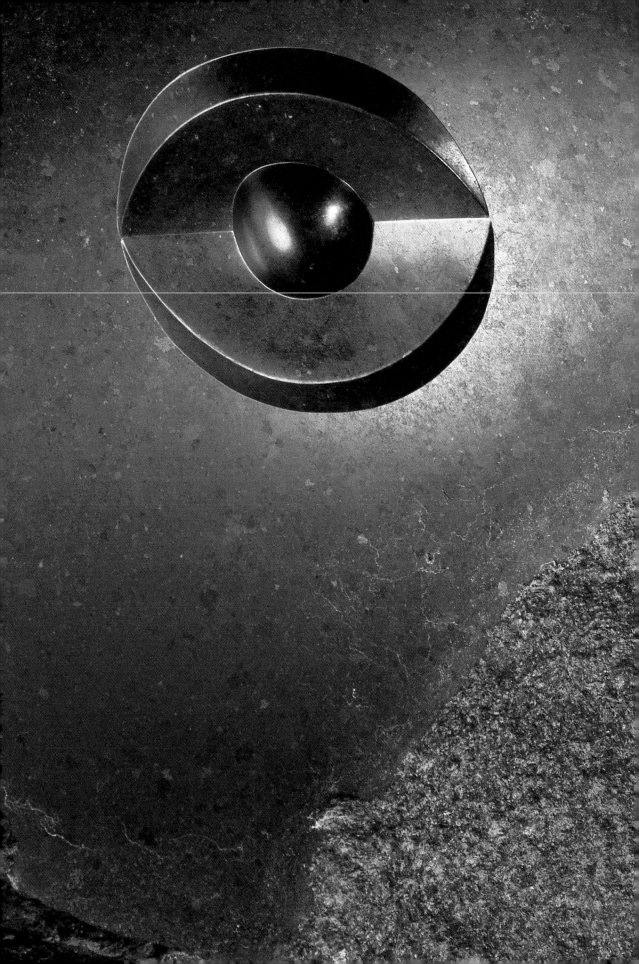

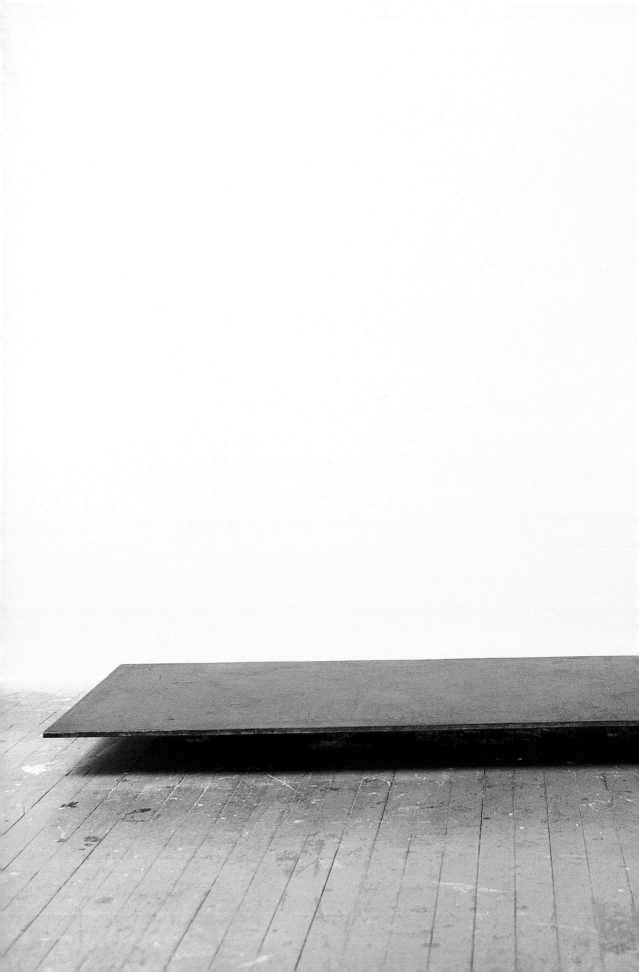

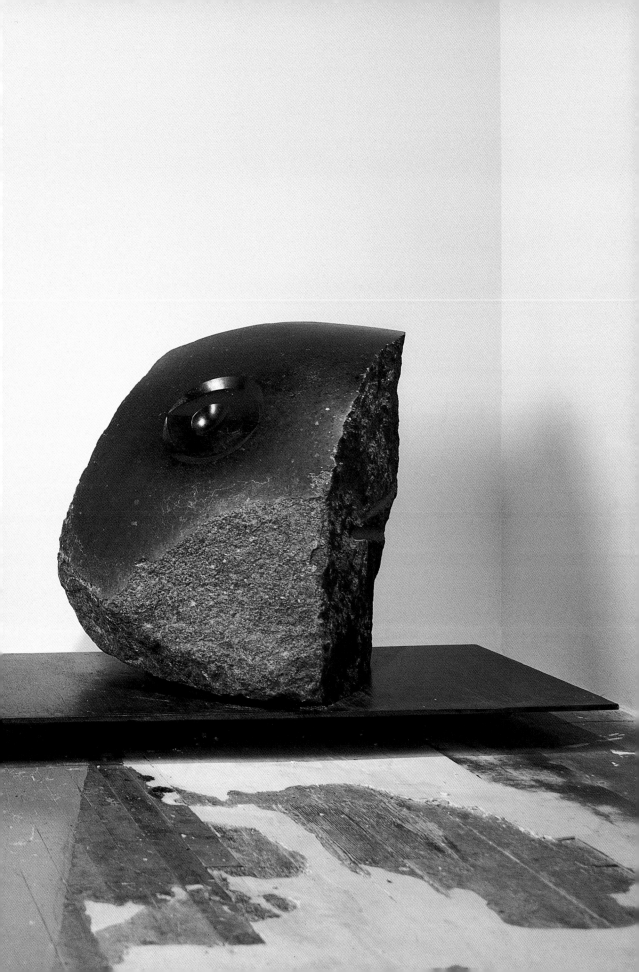

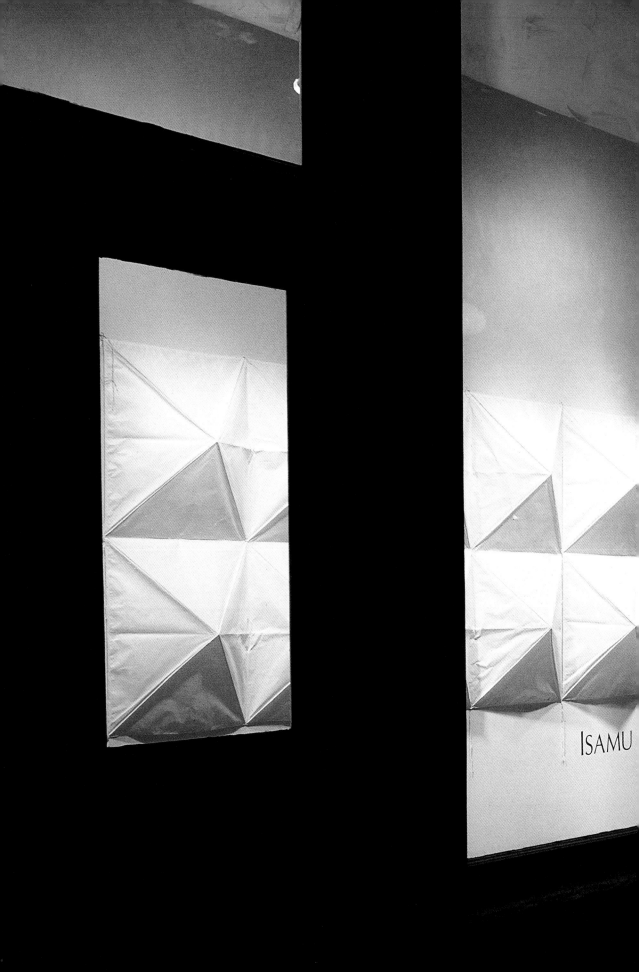

ISAMU

Acknowledgements

My 1999 exhibition of Isamu Noguchi's work was the realization of a long-held dream. Noguchi's work can be elusive, as it is either spread across the globe in prestigious private and museum collections, or installed in his own museums in Long Island, New York, and Mure Takamatsu, Japan. I spent more than three years securing the work that would encompass this sculptor's broad range of expressions and mediums. I thank Ryunosuke Kasahara and Dr. Maclyn Wade for lending their works for this exhibition. They were early believers in Noguchi genius.

Throughout his life, Noguchi worked with architects to achieve his realization of sculptural space. The exhibition I would mount demanded similar collaboration. I could only think of one person that could meet the task, George Suyama. His sensitivity towards both Japanese and American culture, combined with a unique understanding of the urban environment, allowed Suyama to merge calm with chaos and achieve a totally unique vision. He and colleague Jay Deguchi spent many hours conceiving an architectural space that would embrace Noguchi's work in 1999, eleven years after his passing. When Suyama asked Sam Hunter, art historian and personal friend of Noguchi's, what he believed Noguchi would have thought of this exhibit, his response was crisp and immediate, "Noguchi would have flipped." As time passes, current experience and changing perspectives cause artwork to be continually reinterpreted. The fact that Noguchi's work has survived the test of time is mainly attributed to the artist's original creations. Yet I cannot thank the architects enough for adopting this project in spite of their already demanding work and family schedules.

The coordination of this single exhibit required more effort than the actual opening of the gallery back in 1996. Carpets were removed, walls demolished and built, ceilings painted, and metal floors and paper walls installed. Architectural coordination was carefully arranged through the help

of Alyson Owens. Alyson, a former employee and current graduate student at Harvard School of Architecture, rejoined the gallery during the summer of 1999 to facilitate communication between Suyama architects and the gallery. Her scale models were invaluable in realizing the space. Also, many thanks to Erik Sjaastad, who worked into the early morning hours to paint, build, and install the show. I owe gratitude to landscape designer Richard Hestekind, who helped move and position the precious, several-thousand-pound stones of granite. David Gulassa, metal sculptor, lent his skills to add the finishing touches for the sculpture display. Ron Ho and Thomas Batty created a stunning Ikebana arrangement to complement the sculpture.

Thanks to the Seattle Art Museum, through which the exhibit was able to reach so many. Special recognition is owed to Mimi Gardner Gates, Director of the museum, and Trevor Fairbrother, Deputy Director, who acknowledged the importance of this exhibit early on. They enthusiastically hosted a lecture, given by Sam Hunter, at the Seattle Asian Art Museum where Noguchi's *Black Sun* sits prominently in front of the museum. When Hunter agreed to speak in Seattle, he told me he would have had to decline had it been a different city. His fondness for Seattle goes back to the World's Fair in 1962, when he curated the American Modern Art exhibition for the Seattle Art Museum with Virginia and Bagley Wright. He postponed a previously scheduled back surgery in order to accommodate his recent Seattle visit. Thanks to Paula McArdle, whose coordination of lecture logistics helped make it a sold-out event.

During the conception of this book, I realized the strength of Noguchi's ties in Seattle and the Northwest. Seattle's local PBS station, KCTS, was pleased to air a Noguchi documentary as part of their "PBS American Masters Series," with coordination help from Burnill Clark. The local people and places Noguchi influenced helped me incorporate unique Northwest histories into this book.

He created three major public installations here, with the help of architect Ibsen Nelsen. Nelsen remembered Noguchi wondering whether *Black Sun* should be 9 feet or 7 feet in diameter and was quick to help, creating a life-size cardboard replica that helped decide the size. Ibsen's son Eric Nelsen, ceramicist, was a frequent visitor to Noguchi's studio in Mure Takamatsu and was pleased to share with us his valuable visual material for the book. Ayame Tsutakawa (wife of the late George Tsutakawa) and son Jerry Tsutakawa shared their memories of Noguchi's visits with them. Their flood of memories was poignant, but his memory lives on in Ayame's grandson named Kizamu, meaning "sculpt," in the spirit of Noguchi's first name, Isamu.

Finally, I owe tremendous gratitude to the Isamu Noguchi Foundation in New York for their instrumental role in this exhibit. Executive Director Shoji Sadao, Bonnie Rychlak and Douglas De Nicola helped arrange the *Akari* Light Sculpture inclusion in this exhibit. Their insight and resources became an integral part of the success of this exhibition, and for that I am grateful.

So many people gave their time and talents to make this exhibition a resounding success. Such widespread support surely demonstrates the deepest admiration for the life and work of this great artist, Isamu Noguchi.

Designed by Big Kid Design Club
Printed in Japan by Xaravel

Skyviewing Sculpture, Landscape of Time, Black Sun
and exhibit photographed by Richard Nicol;
Noguchi and studio photography, courtesy of Eric Nelsen

He created three major public installations here, with the help of architect Ibsen Nelsen. Nelsen remembered Noguchi wondering whether *Black Sun* should be 9 feet or 7 feet in diameter and was quick to help, creating a life-size cardboard replica that helped decide the size. Ibsen's son Eric Nelsen, ceramicist, was a frequent visitor to Noguchi's studio in Mure Takamatsu and was pleased to share with us his valuable visual material for the book. Ayame Tsutakawa (wife of the late George Tsutakawa) and son Jerry Tsutakawa shared their memories of Noguchi's visits with them. Their flood of memories was poignant, but his memory lives on in Ayame's grandson named Kizamu, meaning "sculpt," in the spirit of Noguchi's first name, Isamu.

Finally, I owe tremendous gratitude to the Isamu Noguchi Foundation in New York for their instrumental role in this exhibit. Executive Director Shoji Sadao, Bonnie Rychlak and Douglas De Nicola helped arrange the *Akari* Light Sculpture inclusion in this exhibit. Their insight and resources became an integral part of the success of this exhibition, and for that I am grateful.

So many people gave their time and talents to make this exhibition a resounding success. Such widespread support surely demonstrates the deepest admiration for the life and work of this great artist, Isamu Noguchi.

Designed by Big Kid Design Club
Printed in Japan by Xaravel

Skyviewing Sculpture, Landscape of Time, Black Sun
and exhibit photographed by Richard Nicol;
Noguchi and studio photography, courtesy of Eric Nelsen